DRAWING DOGS

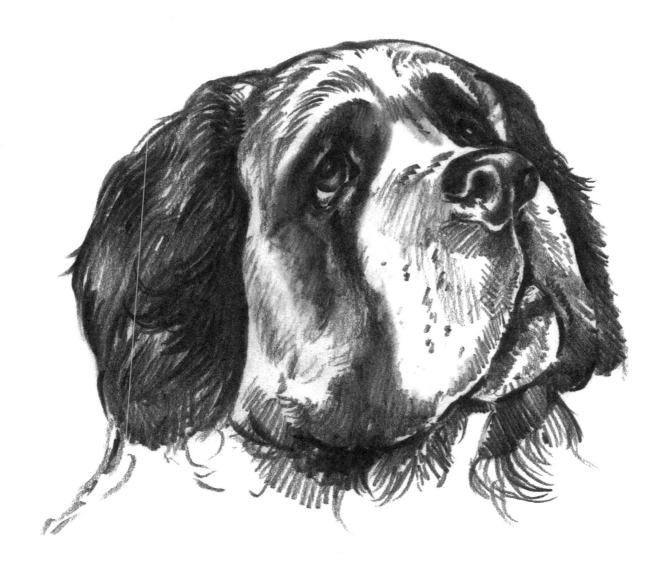

Walter Foster

Walter Foster Publishing, Inc.
23062 La Cadena Drive
Laguna Hills, California 92653

Getting Started

Drawing is just like writing your name. You use lines to make shapes. In the art of drawing, you carry it a bit further, using shading techniques to create the illusion of three-dimensional form.

Only a few basic tools are needed in the art of drawing. The tools necessary to render the examples in this book are all shown here.

Pencils

Pencils come in varying degrees of lead, from very soft to hard (e.g., 6B, 4B, 2B, and HB, respectively). Harder leads create lighter lines and are used to make preliminary sketches. Softer leads are usually used for shading.

Flat sketching pencils are very helpful; they can create wide or thin lines and even dots. Find one with a B lead, the degree of softness between HB and 2B.

Although pencil is the primary tool used for drawing, don't limit yourself. Try using charcoal, colored pencil, Conté crayon, and pastels—they can add color and dimension to your work.

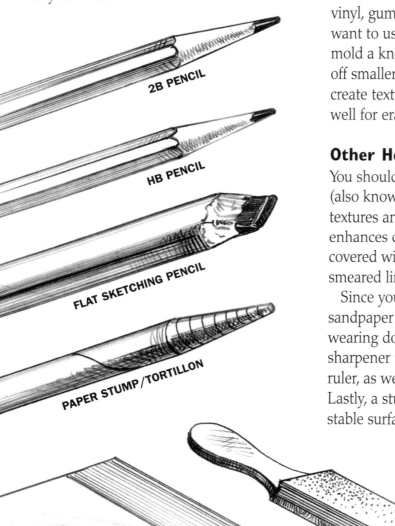

2B PENCIL

HB PENCIL

FLAT SKETCHING PENCIL

PAPER STUMP / TORTILLON

DRAWING BOARD

Paper

Paper varies according to color, thickness, and surface quality (e.g., smooth or rough). Use a sketch pad for practice. For finer renderings, try illustration or bristol board. As you become more comfortable with drawing techniques, experiment with better quality papers to see how they affect your work.

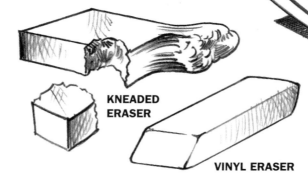

KNEADED ERASER

VINYL ERASER

Erasers

Erasers are not only useful for correcting mistakes, but they are also fine drawing tools. Choose from several types: kneaded, vinyl, gum, or rubber, depending on how you want to use the eraser. For example, you can mold a kneaded eraser into a point or break off smaller pieces to lift out highlights or create texture. A gum or rubber eraser works well for erasing larger areas.

Other Helpful Materials

You should have a paper blending stump (also known as a *tortillon*) for creating textures and blends in your drawing. It enhances certain effects and, once covered with lead, can be used to draw smeared lines.

Since you should conserve lead, purchase sandpaper to sharpen the lead without wearing down the pencil, and buy a regular sharpener too. You may want to buy a metal ruler, as well, for drawing straight lines. Lastly, a sturdy drawing board provides a stable surface for your drawing.

SANDPAPER PAD

Paper (illustration)

METAL RULER

DRAWING PAPER

Final Preparations

Before you begin drawing, set up a spacious work area that has plenty of natural light. Make sure all tools and materials are easily accessible from where you're sitting. Since you might be sitting for hours at a time, find a comfortable chair.

If you wish, tape the paper at the corners to your drawing board or surface to prevent it from moving while you work. You can also use a ruler to make a light border around the edge of the paper; this will help you use the space on your paper wisely, especially if you want to frame or mat the finished product.

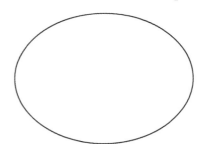

This is an oval *shape*.

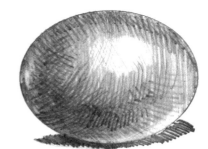

This has a three-dimensional, ball-like *form*.

As you read through this book, carefully note how the words *shape* and *form* are used. *Shape* refers to the actual outline of an object, while *form* refers to its three-dimensional appearance.

Fur Shading Techniques

Shading techniques enable you to transform lines and shapes into three-dimensional objects. By learning how to apply a variety of shading strokes, you will be able to effectively bring out the dog's form and render the texture of the fur.

Dogs of mixed breed, such as the one at the bottom of the page, often exhibit different fur textures. Some areas of fur may be long and wavy, while other areas may be short and smooth. Thus, these dogs are excellent study models.

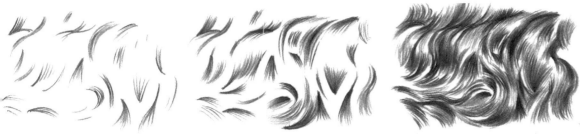

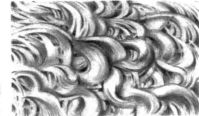
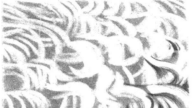
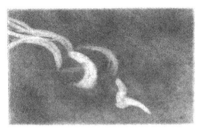

To re-create the thick, wavy fur above (typical of dogs such as golden retrievers), lightly sketch a few short curves in various directions. Develop the texture by adding darker strokes, bringing out sections or individual strands within the coat. When drawing a tight rendering, it's important to work slowly and make each stroke deliberate so the fur doesn't appear sloppy.

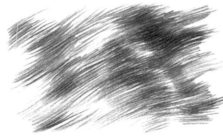

The tight curls above are typical of breeds such as the poodle. To create this texture, use a sharp knife to scrape graphite from a 2B pencil onto the surface. With a soft cloth, gently rub the graphite until the area is a smooth, even gray. Then, use the corner of a kneaded eraser to pull out small curls from the gray until the overall pattern is achieved. Finally, develop the form of the strands by shading with a sharp HB pencil.

FLAT SKETCH PENCIL

ROUND SHARPENED FLAT

TIP OF SHARP ROUND

SIDE OF ROUND

BLUNT ROUND

PAPER STUMP/TORTILLON

Note the different kinds of lines each type of drawing tool produces.

This fur texture appears shorter and smoother than the fur in the examples above and can be found on breeds such as Dalmatians, dobermans, and Labradors. Make your strokes follow the direction of the hair growth, creating a sleek coat. Also, the highlights and shadows are less prevalent here because of the lack of curls and waves in the hair.

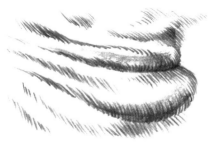
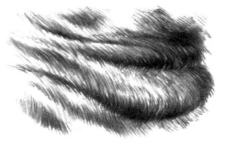

Practice rendering the various types of fur illustrated on this page.

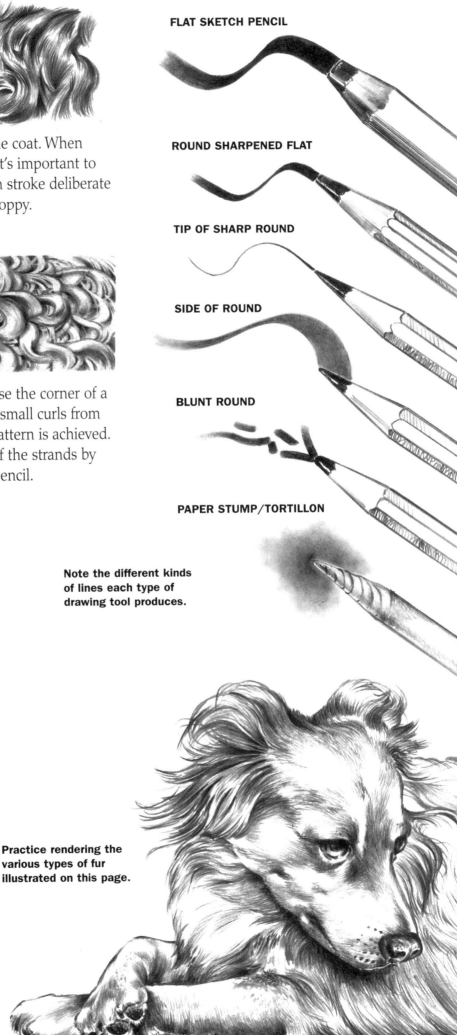

This type of fur is typical of breeds such as the Shar-Pei, covering loose folds of skin. Keep in mind that the shading inside the folds is dark, gradually becoming lighter on top of the folds. It's also important to notice that even by applying strokes in the same general direction, unique textures and forms can be developed through value changes.

Proportion and Anatomy

To accurately render the various dog breeds, it's necessary to draw the body parts in proper *proportion*. Proportion is the correct relation between things or parts in regard to size, quantity, etc. An effective method for establishing proportion is to use one body part as a unit of measurement for determining the size of the other parts. For instance, you can use the dog's head to determine the length and height of the dog's body; the dog to the right is about 4 heads long and 3-1/2 heads high. Make certain the proportions are accurate before working on any details.

Knowledge of basic anatomy will also help you accurately draw your subject. The diagram below illustrates the various parts of the dog. As you study the dogs in this book, notice how these parts differ according to breed. You will have better results if you do so.

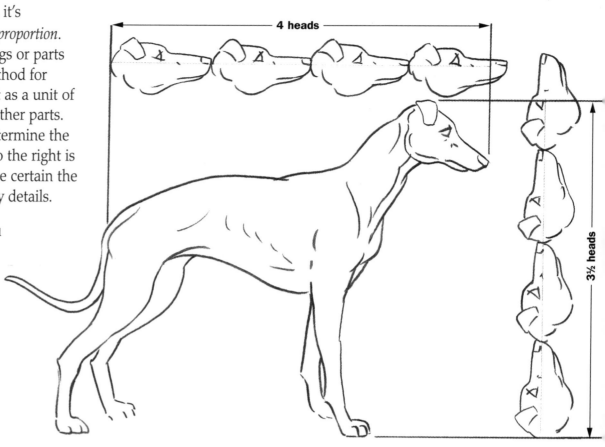

4 heads

3½ heads

Study the various body parts labeled on this page to become more familiar with your subject.

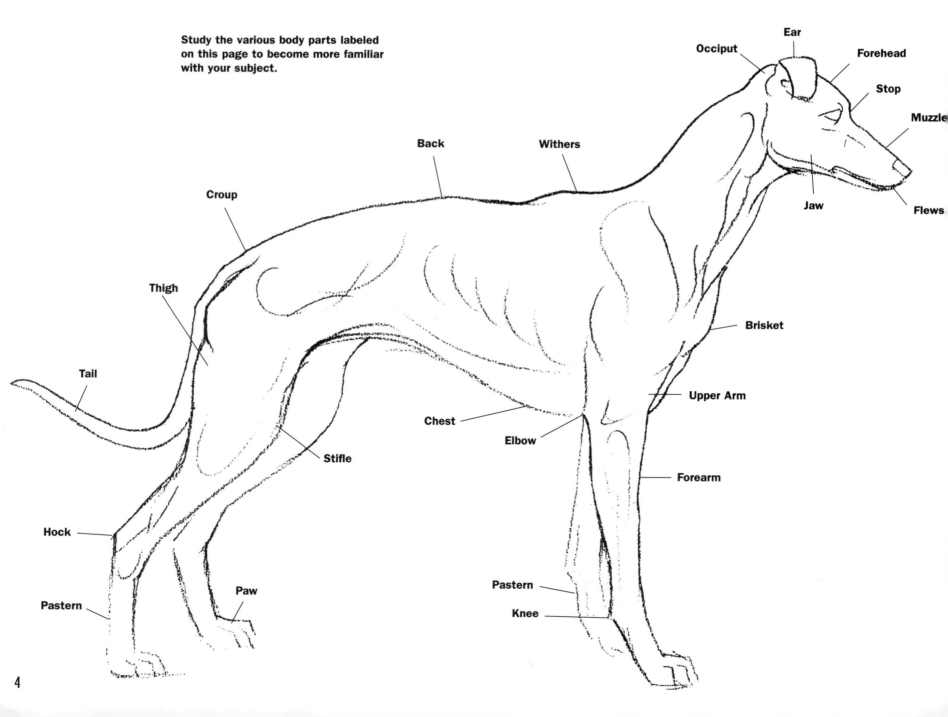

Ear

Occiput

Forehead

Stop

Muzzle

Back

Withers

Jaw

Flews

Croup

Thigh

Brisket

Tail

Upper Arm

Chest

Elbow

Stifle

Forearm

Hock

Pastern

Pastern

Paw

Knee

4

Muscular structure also affects an animal's form, determining where the contours of the body bulge and curve. Therefore, knowledge of muscle construction allows you to shade drawing subjects with better insight, and your work will be more convincing.

The diagrams on this page illustrate the dog's basic muscular structure. Study the muscles closely, and keep them in mind as you draw. As you observe your subject or model, consider how the location of the muscles might affect your shading.

Once the basic drawing is correct, you can begin to develop the details. The illustrations below demonstrate in steps how to render a dog's eye and paw. Begin with very simple lines, and slowly refine the shapes. Use a sharp pencil for bringing out the fine details in the eye and for rendering the fur along the paw. Follow the steps closely to achieve a good likeness.

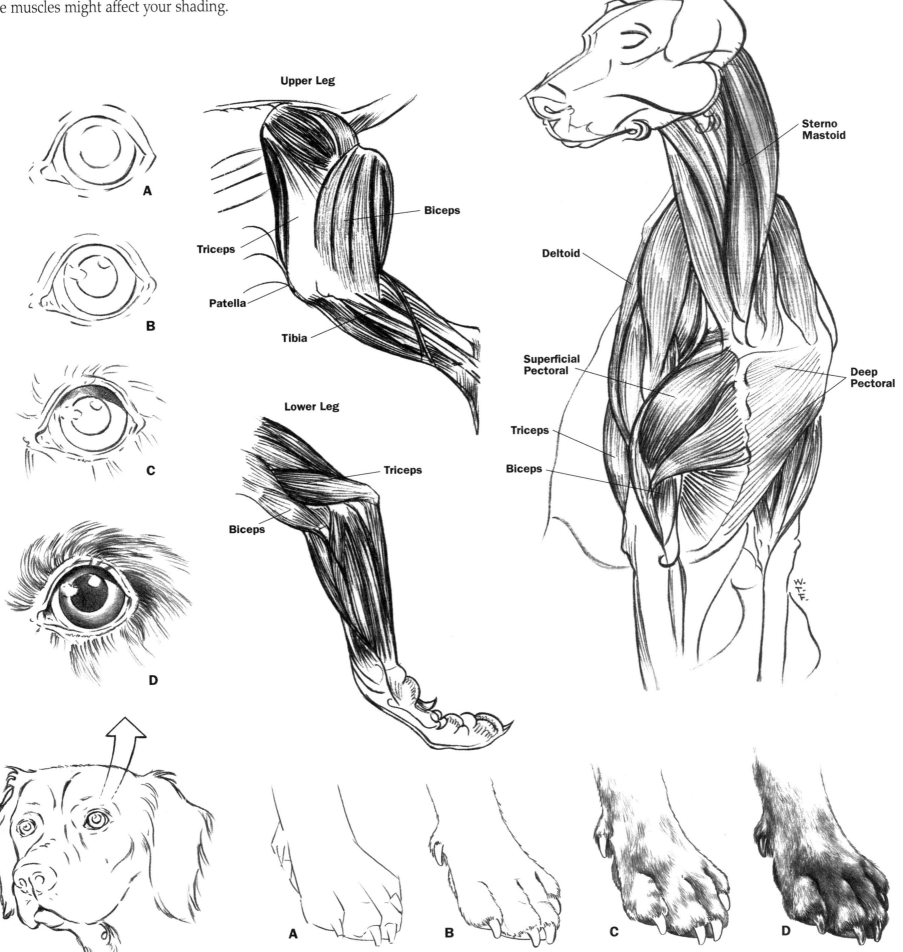

Muzzles

The shapes of dogs' muzzles vary depending on the breed. Study the muzzles of the dogs on this page. Some are long and narrow, while others are short and wide. These characteristics will affect your drawing, so observe your subjects well.

Once you establish the shape of the muzzle, you'll need to draw the nose. To draw the nose, lightly sketch the basic shapes in step A. Then, refine the lines, and begin shading inside the nostrils with a sharp pencil in step B. The shading should be darkest near the inside curve of each nostril. In step C, continue shading the nose, taking note of how the value differences create form. As you draw the fur around the nose, make sure its texture contrasts with the smoothness of the nose. Also, keep in mind that the fur grows outward from the nose, as shown in the final step.

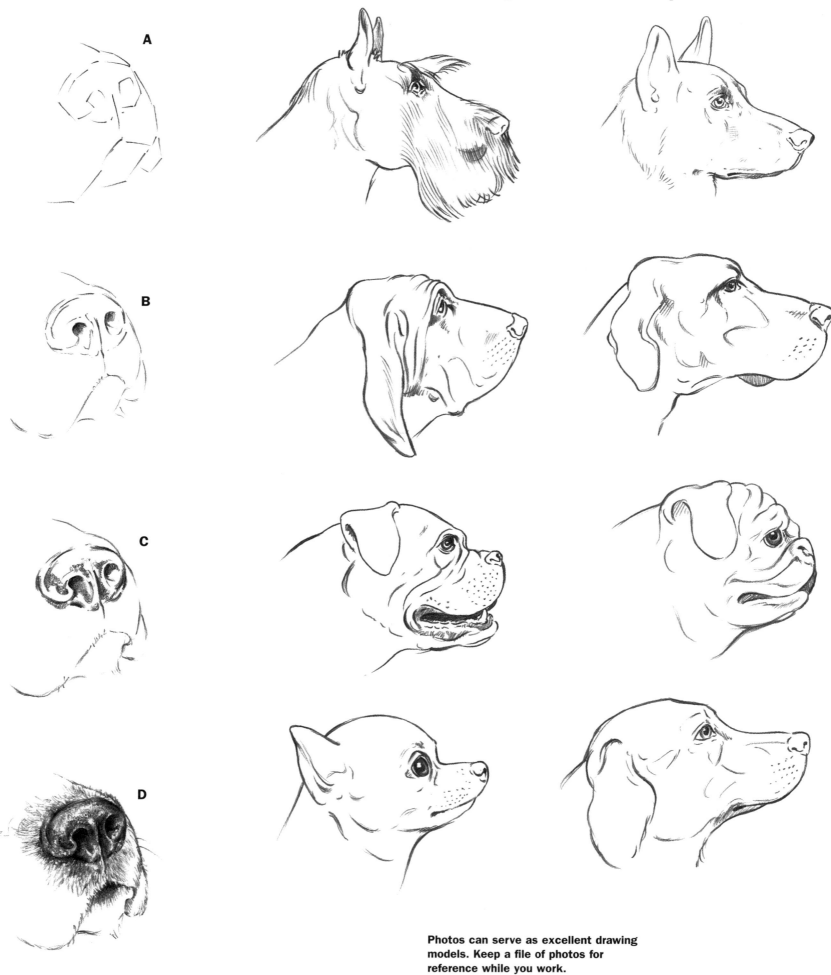

Photos can serve as excellent drawing models. Keep a file of photos for reference while you work.

Dalmation

Dog faces can differ from each other as much as human faces, even within the same breed. Developing astute observation skills will help you create renderings that exhibit personality and achieve a likeness. As you draw, observe your subject closely, and try to discern those characteristics that make the dog unique.

Dalmatians are extremely popular pets and can be fun to draw. Although the renderings on this page are fairly simple, they are still recognizable as Dalmatians. To draw the body, start by blocking in the dog's most basic shapes, as shown in steps A and B along the left side of the page.

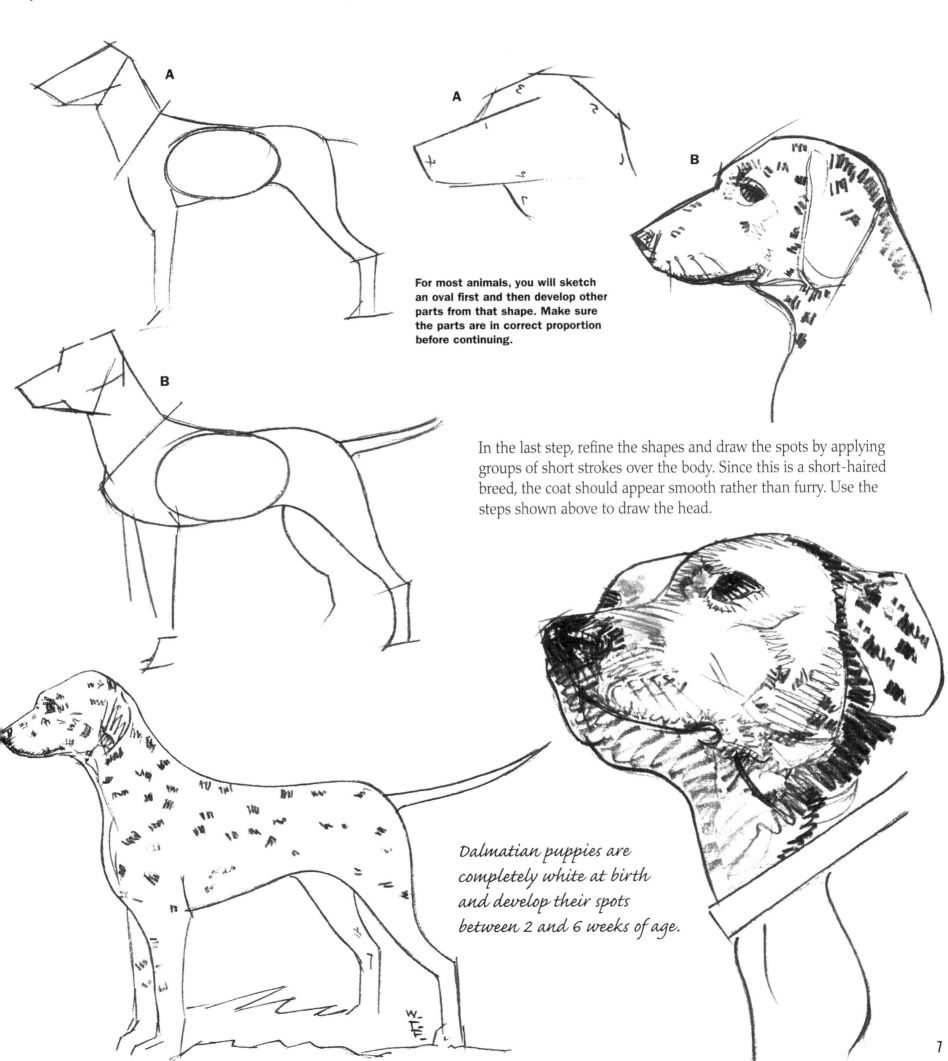

For most animals, you will sketch an oval first and then develop other parts from that shape. Make sure the parts are in correct proportion before continuing.

In the last step, refine the shapes and draw the spots by applying groups of short strokes over the body. Since this is a short-haired breed, the coat should appear smooth rather than furry. Use the steps shown above to draw the head.

Dalmatian puppies are completely white at birth and develop their spots between 2 and 6 weeks of age.

Great Dane

Great Danes have elegant stature and unique faces. While their enormous size (they can grow up to 30 inches) may be slightly intimidating, they are actually very gentle and affectionate, especially with children.

In steps A and B, use an HB pencil to block in the dog's large head. Notice the droopy lips and eyelids, which give the Great Dane a pleading expression. Refine the shapes, and lightly shade with a 2B pencil to bring out the form and contours of the head in step C. The minimal shading will give the coat a smooth appearance.

Add darker values within the center of the ear to create the curvature of the ears, "carving out" the area through skillful shading, as shown in the final drawing. To enhance the shine of the nose, shade it evenly, and use a kneaded eraser to pull out highlights.

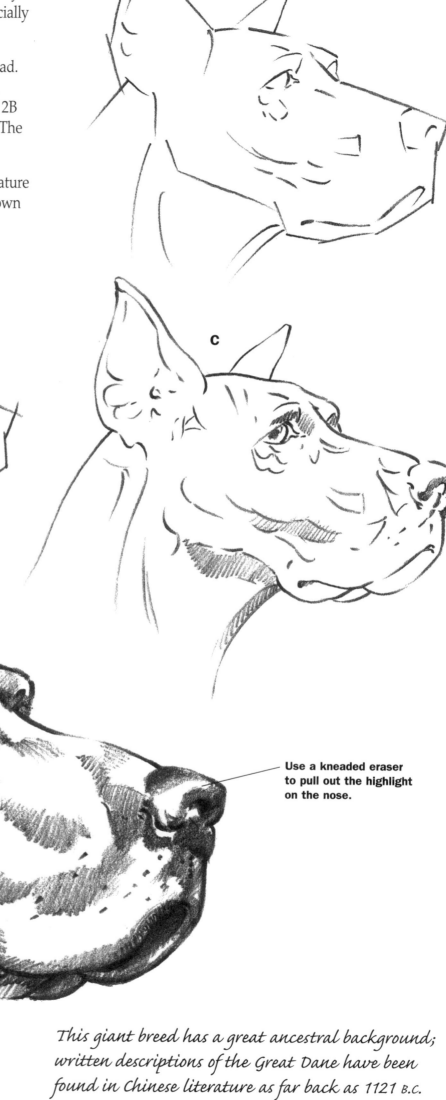

B

A

The erect ears can be developed from simple triangle shapes.

C

Use a kneaded eraser to pull out the highlight on the nose.

This giant breed has a great ancestral background; written descriptions of the Great Dane have been found in Chinese literature as far back as 1121 B.C.

English Setter

The English setter is a beautiful, dignified sporting breed with a soft, wavy coat. The coat requires careful grooming to look its best.

First block in the basic shape of the full body or head. Once you are satisfied with the preliminary sketch, you'll find it easy to create form and suggest fur with short, deliberate strokes, as shown in the final drawings. These renderings were done with a loose, sketchy style that focuses on capturing the dog's essence rather than every small detail.

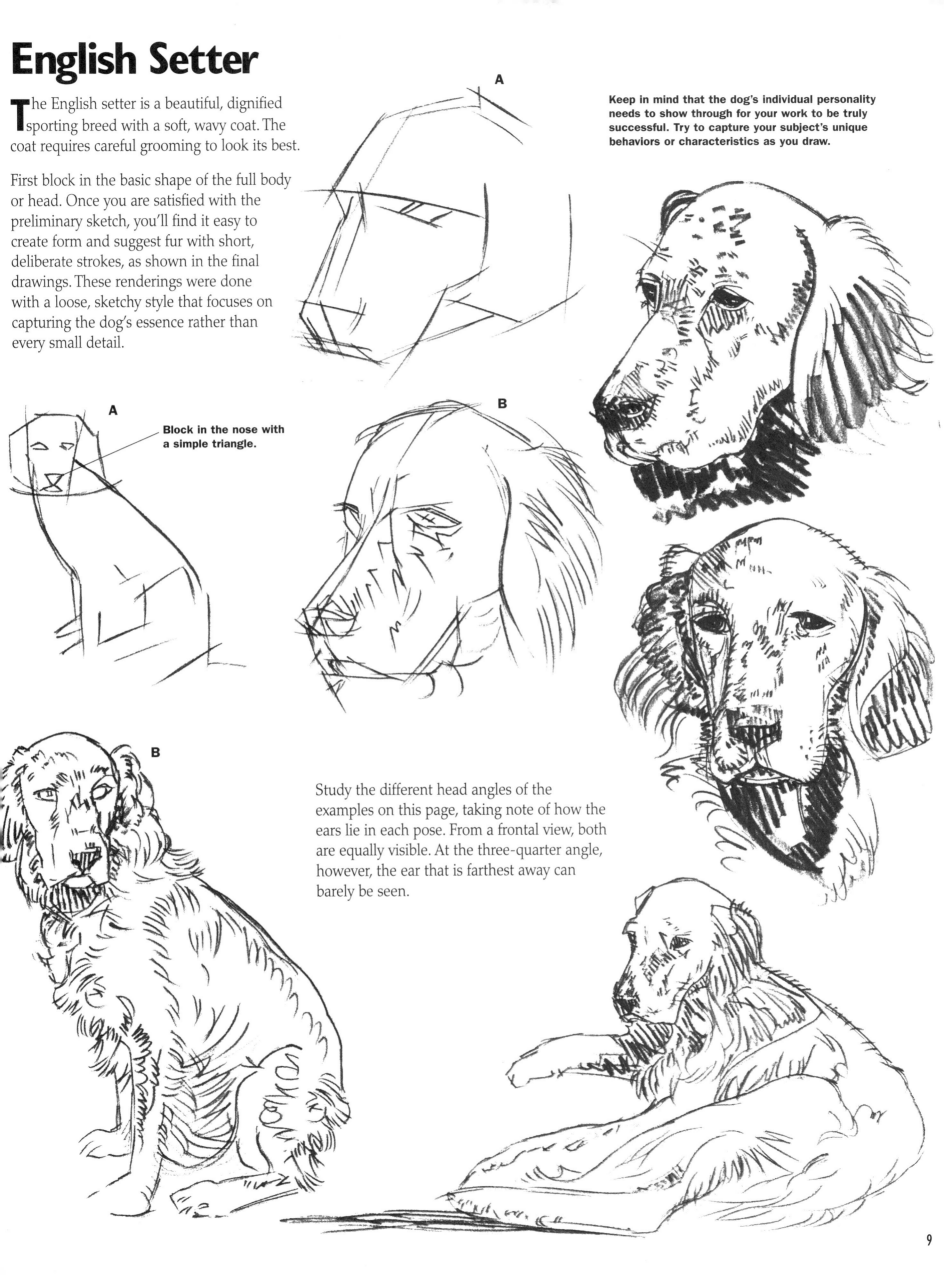

A

Keep in mind that the dog's individual personality needs to show through for your work to be truly successful. Try to capture your subject's unique behaviors or characteristics as you draw.

A

Block in the nose with a simple triangle.

B

B

Study the different head angles of the examples on this page, taking note of how the ears lie in each pose. From a frontal view, both are equally visible. At the three-quarter angle, however, the ear that is farthest away can barely be seen.

Irish Setter

To capture the active disposition of an Irish setter puppy, it's best to find a live model to study its mannerisms and expressions. Although the puppies are often shy, if you treat them kindly, they will quickly learn to show affection.

In step A, sketch the outline of the head with an HB pencil, paying attention to the position of the eyes. At a three-quarter view, one eye is less visible than the other. Begin to develop the facial features in step B, along with the longer hairs.

Use a brush and ink to draw the fur, keeping in mind the narrow form of the head. Leave tiny white areas for the highlights in the eyes. This allows you to create an expression unique to the individual dog.

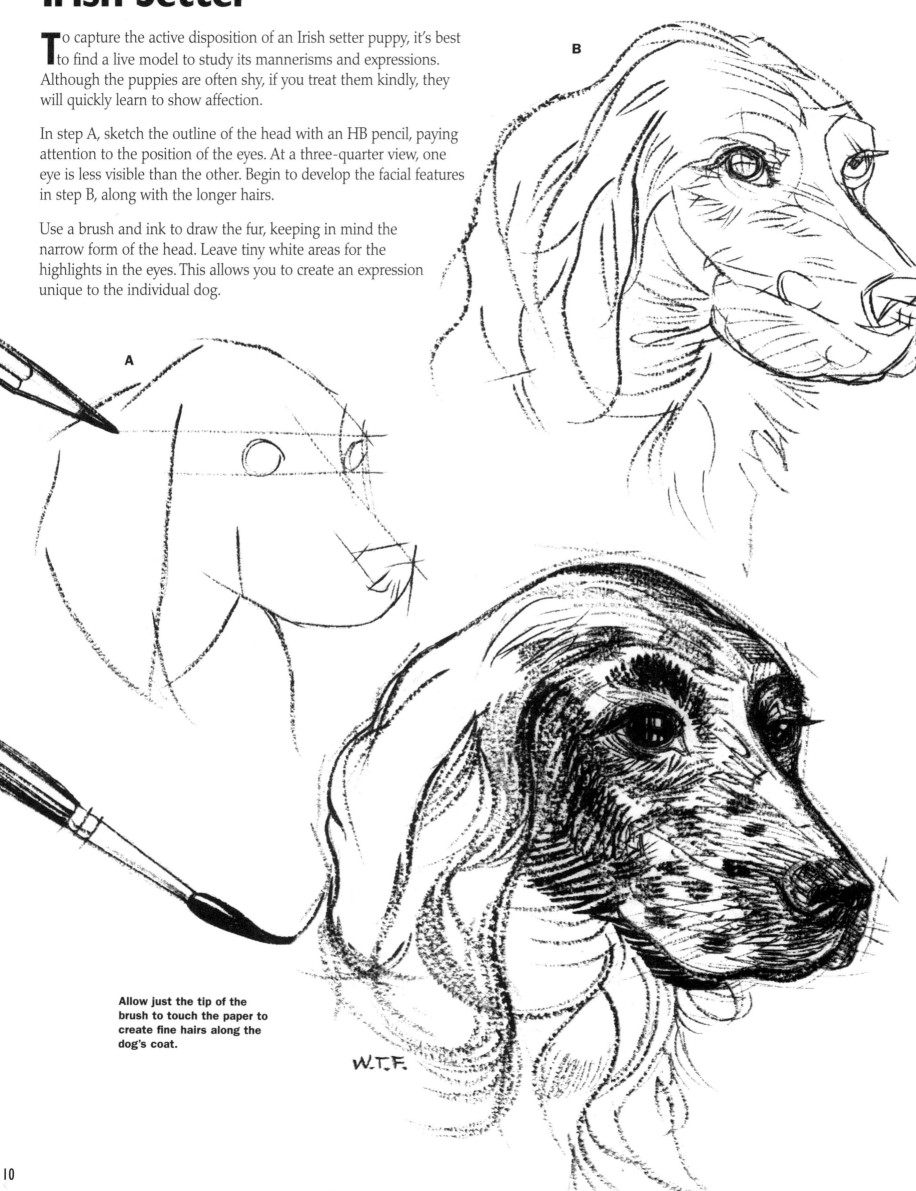

Allow just the tip of the brush to touch the paper to create fine hairs along the dog's coat.

W.T.F.

Mature Irish setters have a narrower, more elongated face. As before, block in the shape in step A with an HB pencil. These lines establish the dog's pose. In step B, further develop the various body parts, defining the shape of the dog.

As you add details in the final step, keep in mind the texture of the coat. Use long, flowing strokes to bring out the lush, silky hair. You can add more shading layers to indicate the dark red color.

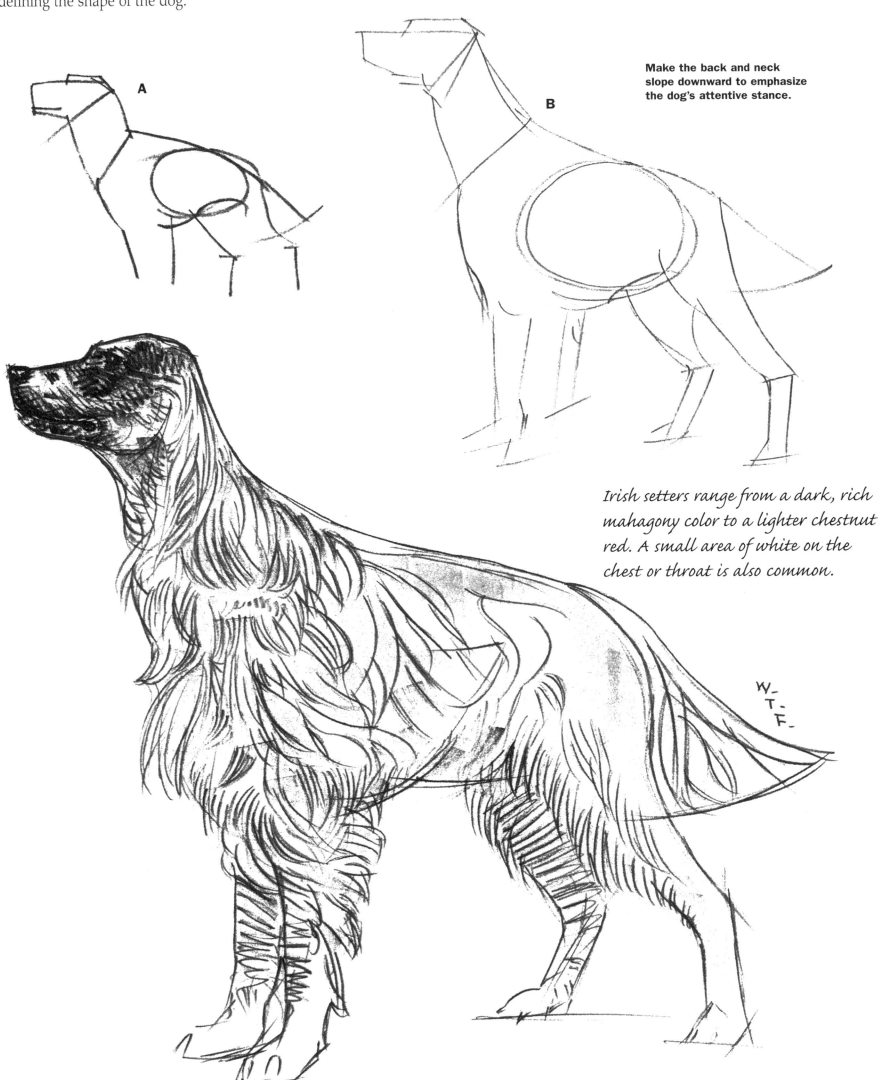

Make the back and neck slope downward to emphasize the dog's attentive stance.

Irish setters range from a dark, rich mahagony color to a lighter chestnut red. A small area of white on the chest or throat is also common.

Yorkshire Terrier

The Yorkshire terrier is a popular household pet with a silky coat and perky ears. This long-haired breed may seem more difficult to draw because the actual forms of the head and body aren't visible. Most of the drawing will be done by rendering the dog's silky coat. You can use the eyes and nose as starting points for adding the hair.

Block in the head with a few straight lines, as shown in step A. In steps B and C, build the features on the initial lines. Once the basic essence of the hair is established, use the side of a black Conté crayon to shade the bare areas and make the coat appear thicker. Since most of the drawing is done by shading the fur, you don't need to develop the actual form of the dog's body.

Next, add long hairs around the face. Remember to apply strokes in the direction of the hair growth and to block in areas for the highlights in the eyes.

Because its long coat can completely hide the legs and feet, a Yorkshire terrier may look as though it's moving on wheels!

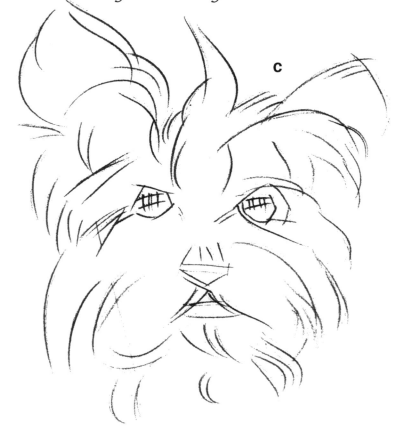

Maltese

This toy breed has a long, white coat and round, black eyes. Like the Yorkshire terrier, the Maltese is rendered mostly by developing its long coat.

Only a few simple strokes are needed to suggest the shape of the head. In step A, begin with a rectangle and guidelines drawn in the numbered order shown. Make certain the lines provide accurate placement for the features. In step B, lightly sketch the eyes and nose on the block-in guides.

In step C, begin adding fur using long flowing strokes in the direction of the hair growth. Note how the minimal amount of strokes makes the dog appear white. Use a sharp pencil or a thin brush and ink to add fine details to the eyes and nose. Again, leave white areas for the highlights in the eyes.

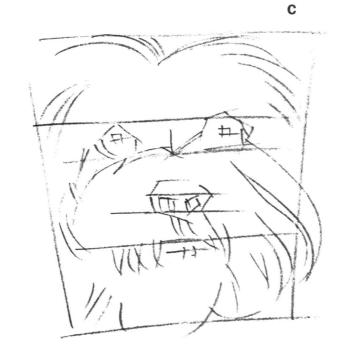

C

A curtain of hair often covers the eyes of these dogs, which were prized by the ancient rulers of Malta.

A

B

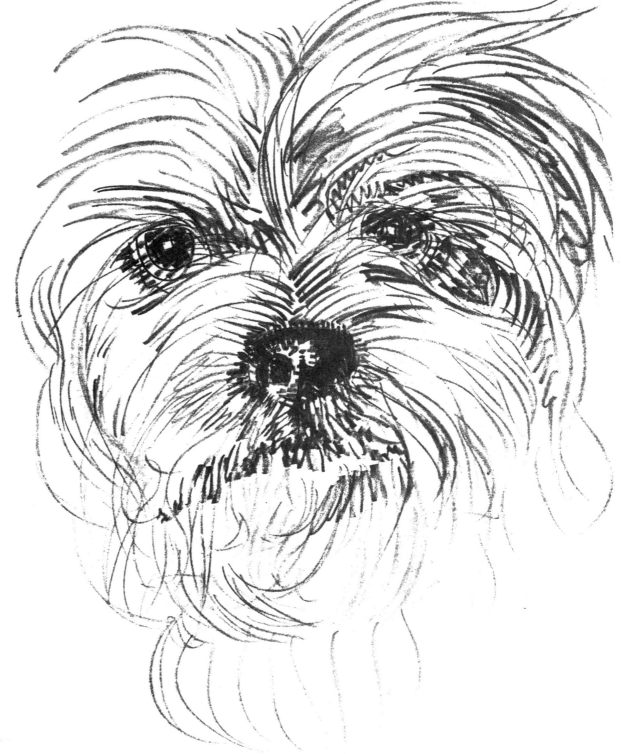

Bloodhound

The bloodhound is distinguished by its long, floppy ears, sad eyes, and loose skin. This breed may have a melancholy expression, but it's known as a gentle companion.

In step A, use an HB pencil to sketch each line in the numbered order indicated. Continue to block in the basic shapes in step B, including the facial features. Keep in mind that the eyes angle slightly downward.

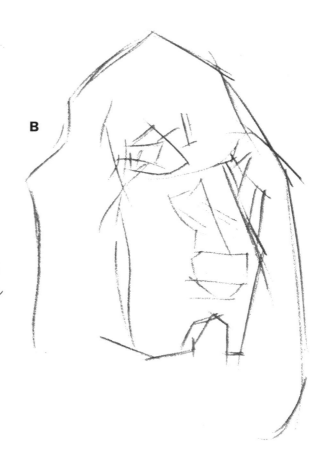

The bloodhound, with its incredible tracking ability, has been known to follow a 14-day-old scent for more than 138 miles!

In step C, smooth out the block-in lines, and begin to sketch the folds and wrinkles along the face. Use the side of a black Conté crayon to add a sparse layer of shading over the face. In the final stage, refine the form by shading with a soft 2B or 4B pencil, especially within the wrinkles. Use heavy shading lines to develop the contours of the dog's face and create a sad expression.

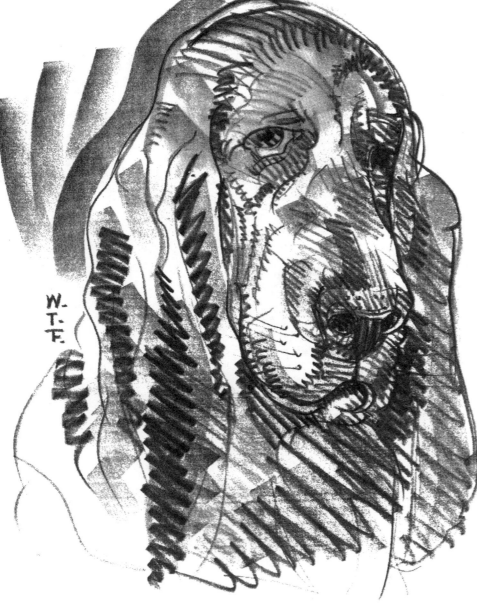

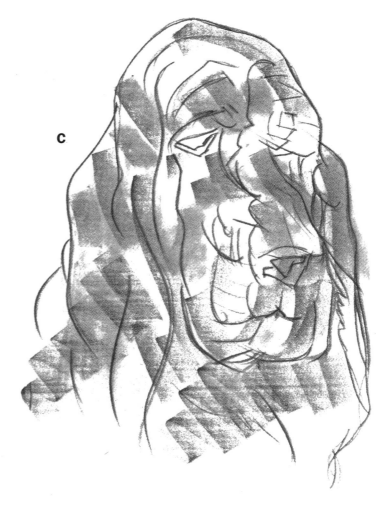

Since many dogs are similar, the smaller details should capture the essence of the breed's physical traits. It's important that the various dogs are drawn and shaded with different techniques.

Dachshund

The dachshund is a hound with short legs and a long, sturdy body. It can be smooth-, wire-, or long-haired. This example is a profile of a smooth-haired dachshund.

Use an HB pencil to block in the general shape in step A, smoothing out the lines in step B. Add the facial features in step C, using a blunt 2B pencil or round watercolor brush and India ink. These tools will produce heavy, solid lines, which are good for dark areas, such as the eye and nose.

In step D, bring out the form of the head using a soft pencil sharpened to a chisel point, and add finer details with a brush and ink. You can also use the side of a black Conté crayon to create gray values over larger areas, as shown in the finished drawing.

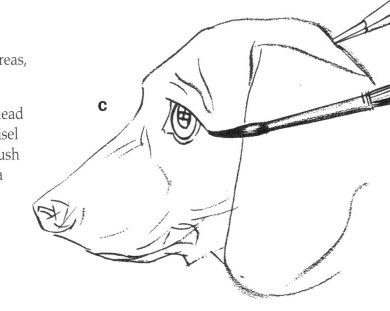

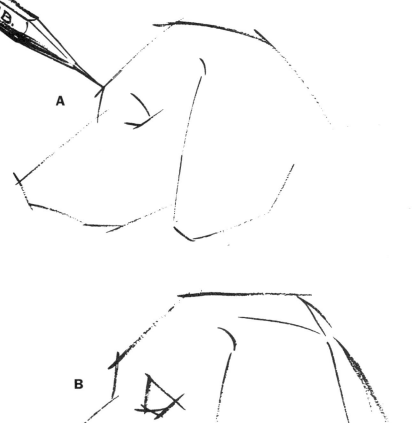

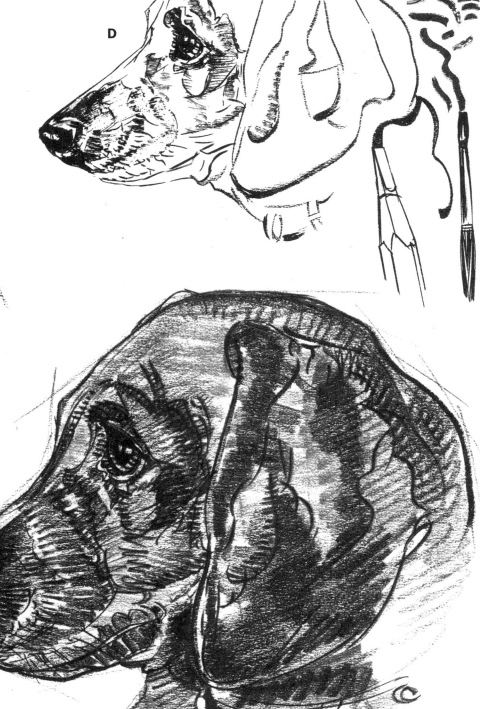

The dachshund is also known as a "wiener dog" because of its elongated body.

WALTER T. FOSTER

German Shepherd Dog

The German shepherd dog is one of the most popular breeds in the world. Because it is a very intelligent breed, it is often trained to perform specialized jobs, such as search and rescue, bomb or drug detection, and home or personal protection.

In step A below, make a light outline sketch, paying attention to the size of the ears in comparison to the head. The curious, attentive look is emphasized by the wide eyes and alert ears. The dog's strength is conveyed by the thick, muscular neck. Once the block-in sketch is correct, use the side of a pencil lead or charcoal to create broad shading strokes.

For the body, start with an simple oval, and lightly develop the rest of the parts. Check the neck and head angle before applying shading or details.

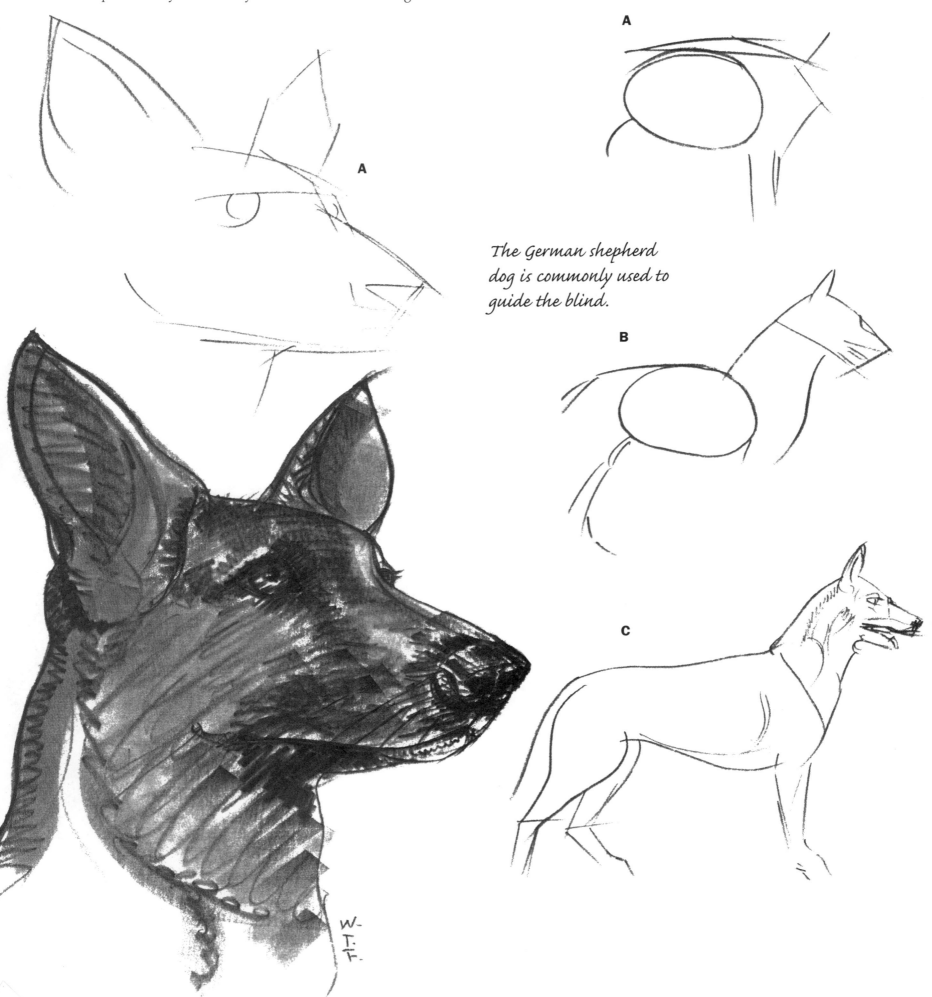

A

The German shepherd dog is commonly used to guide the blind.

A

B

C

Saint Bernard

The Saint Bernard is a giant, massively proportioned working breed. Both smooth- and rough-haired types exist, so closely study the specific dog you're drawing. Notice that this example was drawn in a tightly rendered style with fine details.

In step A, sketch the general shape of the head with short, simple lines. Refine the lines to develop the head and facial features in step B. Slant the eyes downward to give the dog its gentle expression.

In step C, lightly shade over the areas where the fur is darker, such as on the ears and around the eyes. As you begin to add more detail, make note of the difference in fur texture between the ears and the face—the ears have long, full hair, while the face has short, smooth hair.

A

B

C

When working in black and white, you can create the illusion of color through a variety of white, gray, and black values.

Study the close-up of the eye below. The fur around the eye was shaded with rough strokes, while the eye itself was shaded with more refined lines. The eye, therefore, appears smooth and glossy in contrast to the fur. A sharp pencil also helps create intricate details, such as the pupil and corner of the eye.

Rough Collies

Although collies can be found in many households, they are also well-known as herding dogs in Scotland, Ireland, and England. They have long, pointed muzzles, virtually no stop, and a slightly wavy, thick coat. This rendering was done with a loose, free approach to create an artistic feel. As you develop your skills, your own artistic style will emerge.

In step A, block in the simple shape of the collie's profile with an HB pencil. Be sure the eye is correctly positioned; otherwise, your drawing won't be accurate. In step B, lightly sketch the nose, mouth, and ears. Don't worry about details at this stage; most will be determined as you develop the fur. Use the very tip of a brush and India ink to create loose, thin strokes.

The most famous rough collie of all was Lassie, who starred in many television shows and movies.

A

B

W.J.F.

This drawing shows a different view of the collie's head. The muzzle appears especially long and narrow from this angle. Follow steps A and B to block in the basic shape. Begin shading with charcoal and a chisel-pointed 4B pencil. Render the darker fur along the top of the head with short, firm strokes, and use longer, well-placed strokes for the mane. Keep in mind that the fur grows upward and outward, making it appear fluffy and full.

The origin of this breed dates back to the 1500s in Great Britain.

A chisel-pointed 6B pencil will make dark, broad lines. These lines should follow the direction of fur growth.

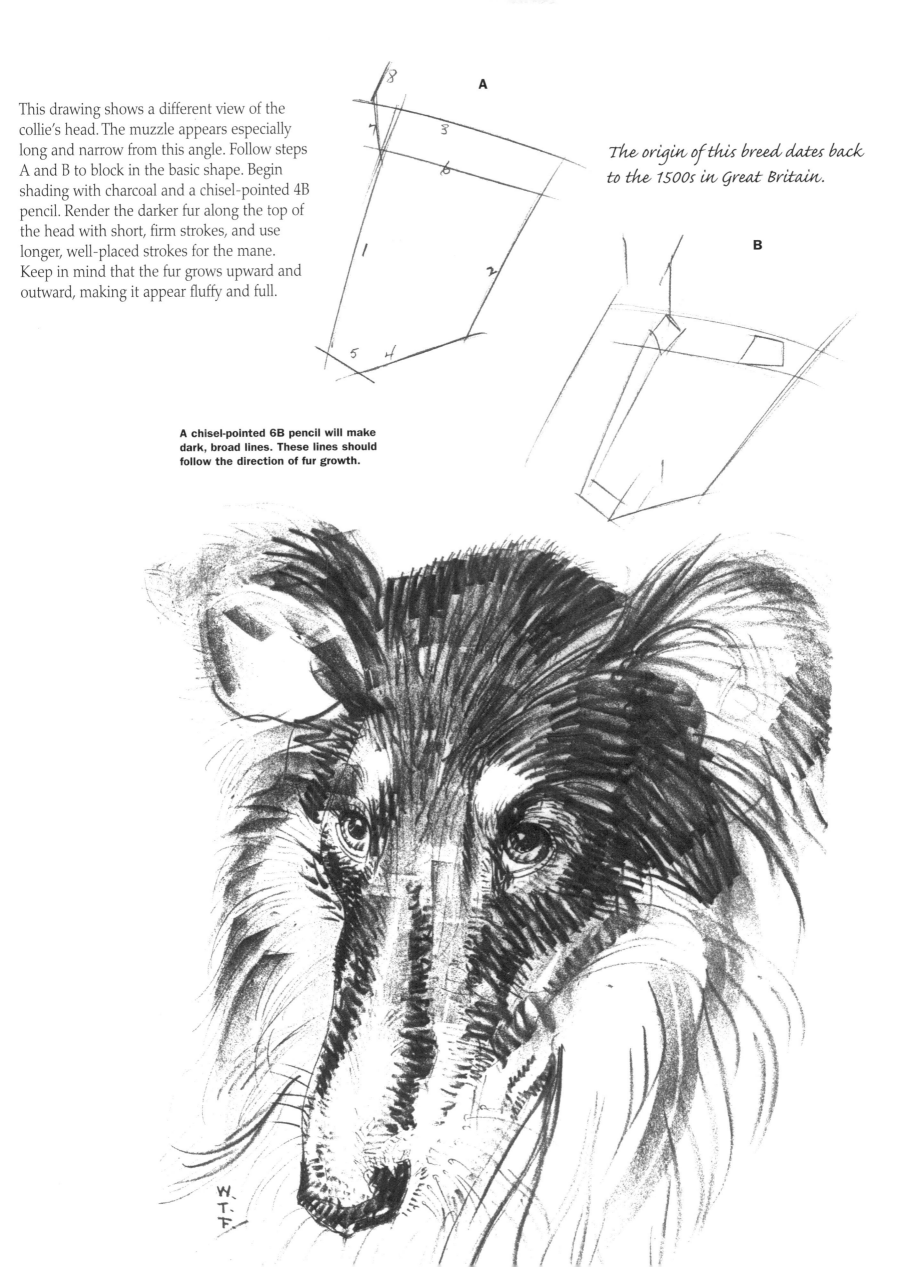

A

B

Springer Spaniel

The wavy coat and friendly expression of the springer spaniel make it challenging to draw. Sketch the block-in shapes with an HB pencil using straight lines, as shown in step A. Be sure the sketch is accurate before continuing.

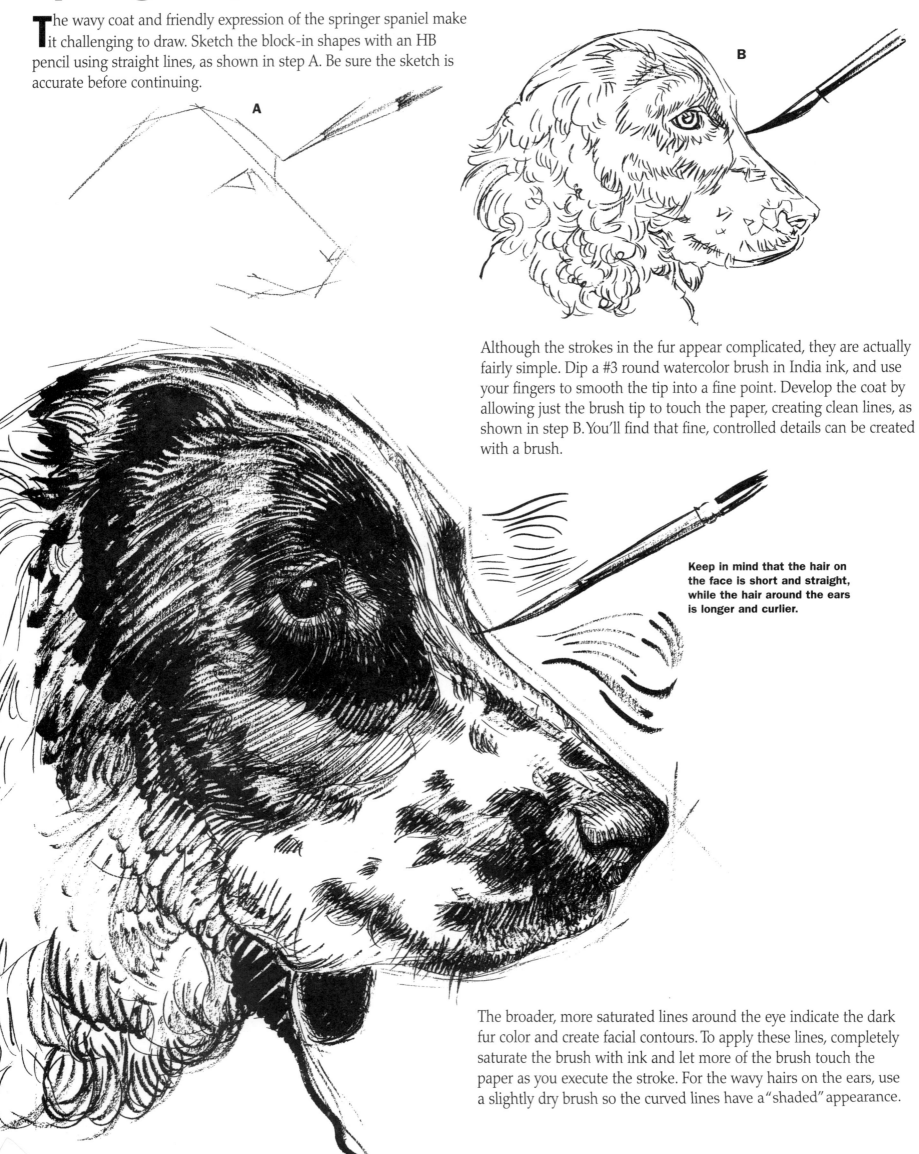

Although the strokes in the fur appear complicated, they are actually fairly simple. Dip a #3 round watercolor brush in India ink, and use your fingers to smooth the tip into a fine point. Develop the coat by allowing just the brush tip to touch the paper, creating clean lines, as shown in step B. You'll find that fine, controlled details can be created with a brush.

Keep in mind that the hair on the face is short and straight, while the hair around the ears is longer and curlier.

The broader, more saturated lines around the eye indicate the dark fur color and create facial contours. To apply these lines, completely saturate the brush with ink and let more of the brush touch the paper as you execute the stroke. For the wavy hairs on the ears, use a slightly dry brush so the curved lines have a "shaded" appearance.

Afghan Hound

The Afghan hound got its name in the 1800s when soldiers returning from the Afghan War brought it home to Europe. It is a very athletic hunting dog.

The process for rendering an Afghan hound is very similar to the springer spaniel. However, the Afghan requires more consistent shading strokes. Also, keep in mind that the muzzle of this breed is longer and narrower than that of the springer spaniel.

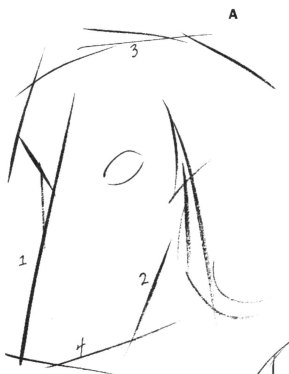

The direction of your strokes are vital for bringing out the form of the head. For example, the fur grows outward from the eyes; therefore, your brush strokes should do the same.

Use minimal shading to fill in the eyes, making them appear glossy. The highlight is necessary for creating an accurate resemblance, as well as for giving life to the drawing. Otherwise, your subject may look like a stuffed toy rather than a living dog.

The long, silky coat of the Afghan requires constant grooming and care to look its best.

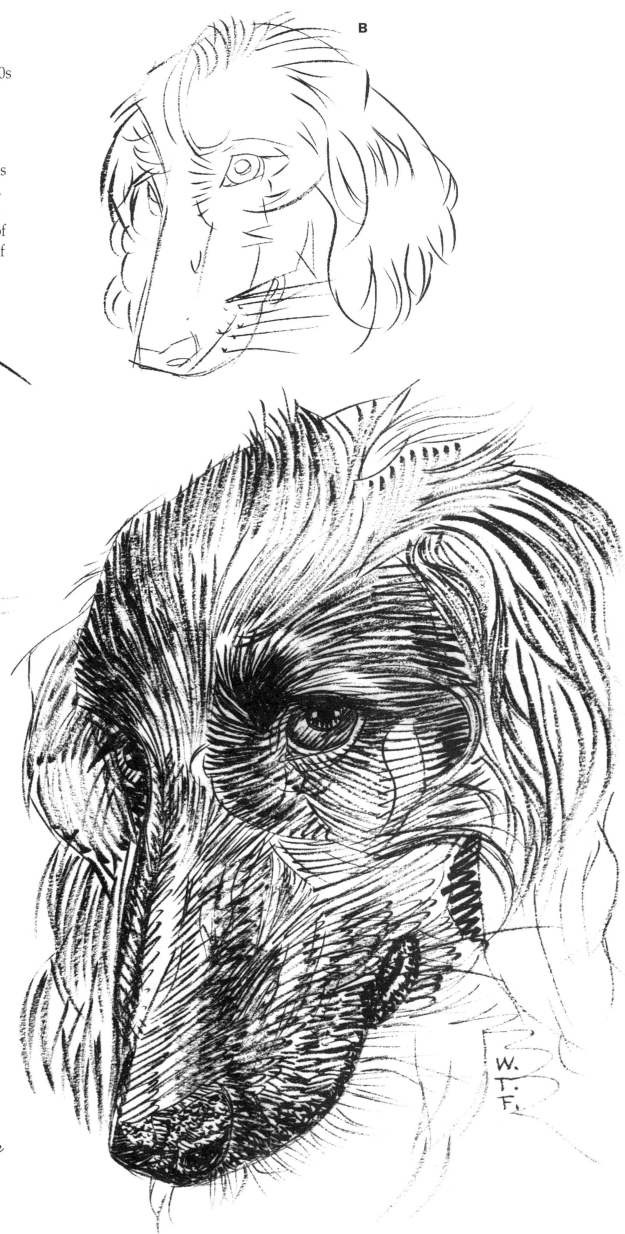

Boston Terrier Puppy

The Boston terrier is an American breed with a pushed-in face and slightly protruding eyes. This particular rendering is a Boston terrier puppy. Even at full maturity, this breed's large ears appear too big for its head.

In step A, use charcoal or pencil to sketch the basic shapes of the head. Notice that one of the ears in this drawing is pointed upward, while the other falls forward slightly; thus, their block-in shapes will differ. In step B, add the facial features, and indicate the darker areas of the fur, as shown.

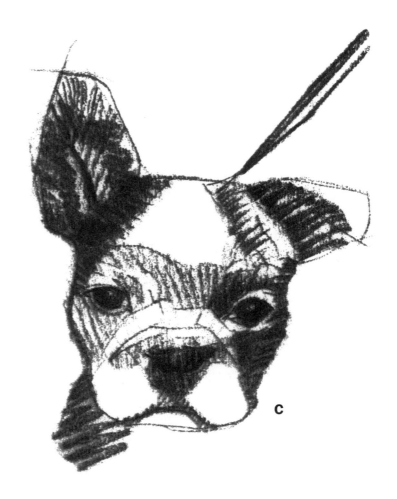

C

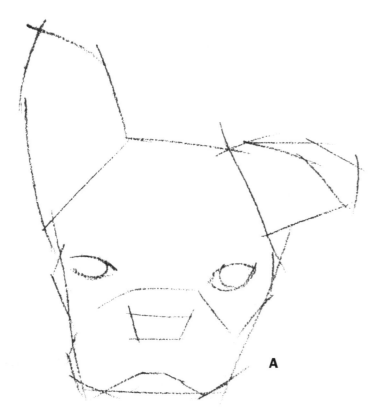

A

If charcoal accidentally smears into areas you wish to remain white, use your kneaded eraser to clean them.

Use charcoal to begin shading in step C, darkening the ears and nose. The darkest areas should be the eyes. In step D, use a paper stump to develop the contours around the nose and mouth. Also, shade the background, blending the area evenly with a paper stump. This creates a backdrop for the dog, framing the face and allowing it to pop off the page.

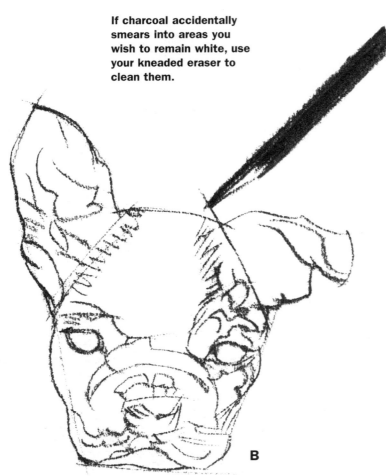

B

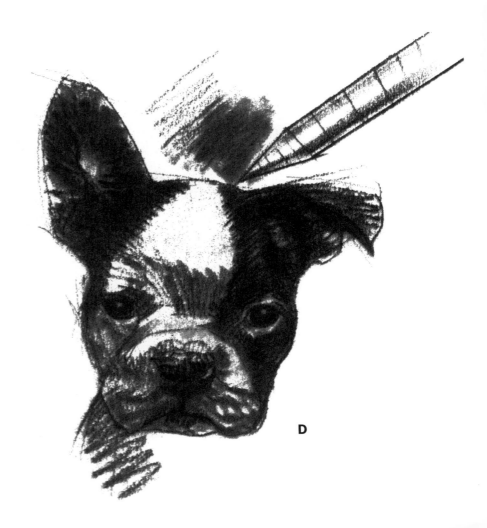

D

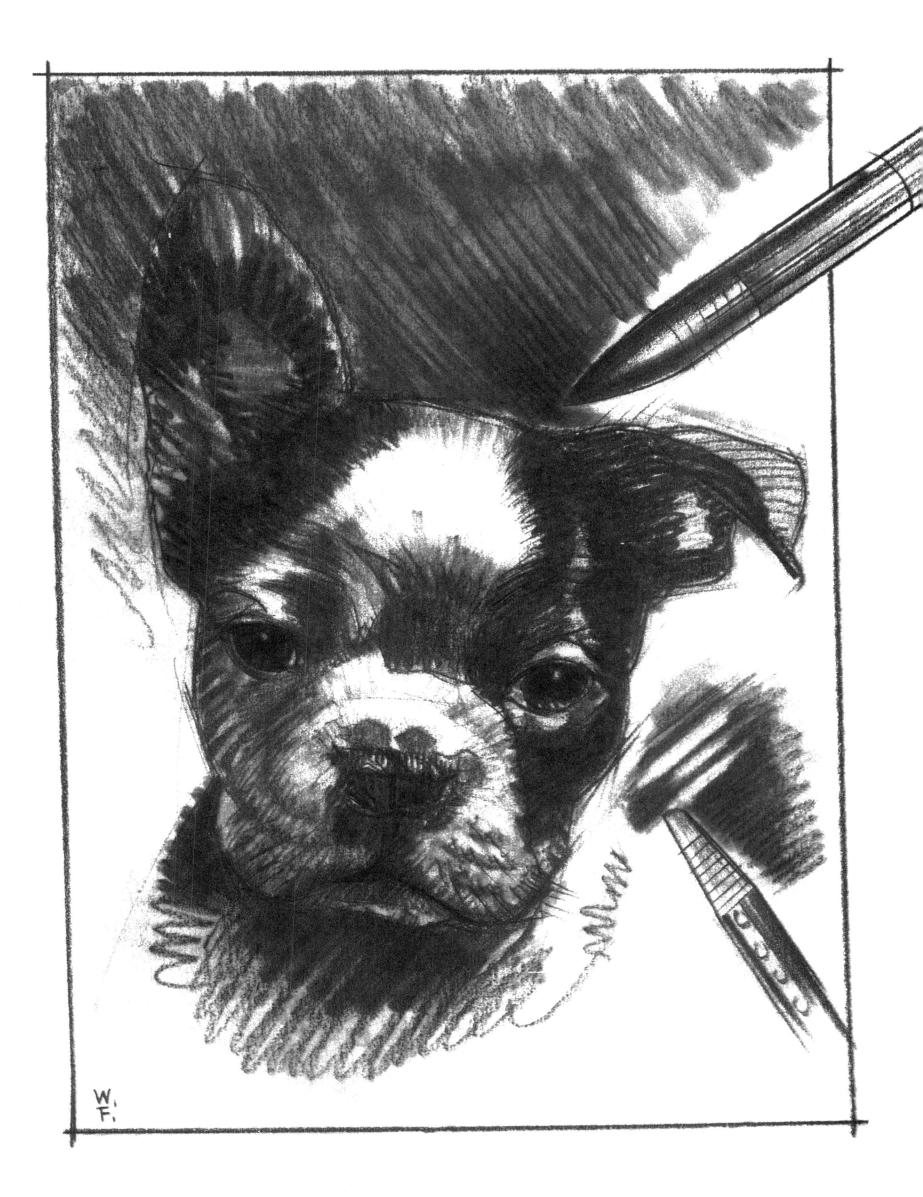

Cocker Spaniel

Cocker spaniel puppies are great drawing subjects because they have charming personalities. This breed is a very popular pet, so live models or photos shouldn't be too hard to locate.

Follow the numbered order shown in step A to place your block-in lines. These lines will help you determine the position of the facial features in step B.

Begin shading in step C with a 6B pencil sharpened to a chisel point, which will produce dark, solid lines. Allow the fur texture to emerge by drawing short quick strokes in the direction of the hair growth. The strokes around the nose, for example, "radiate" outward from the nose. Then use the side of a black Conté crayon or charcoal, and loosely swipe it over the areas where you see even, gray values. Study the shading in the final drawing, and make note of the darkest areas. These areas create the contours and form of the dog.

Keep your strokes relatively loose and free as you develop the dog's form.

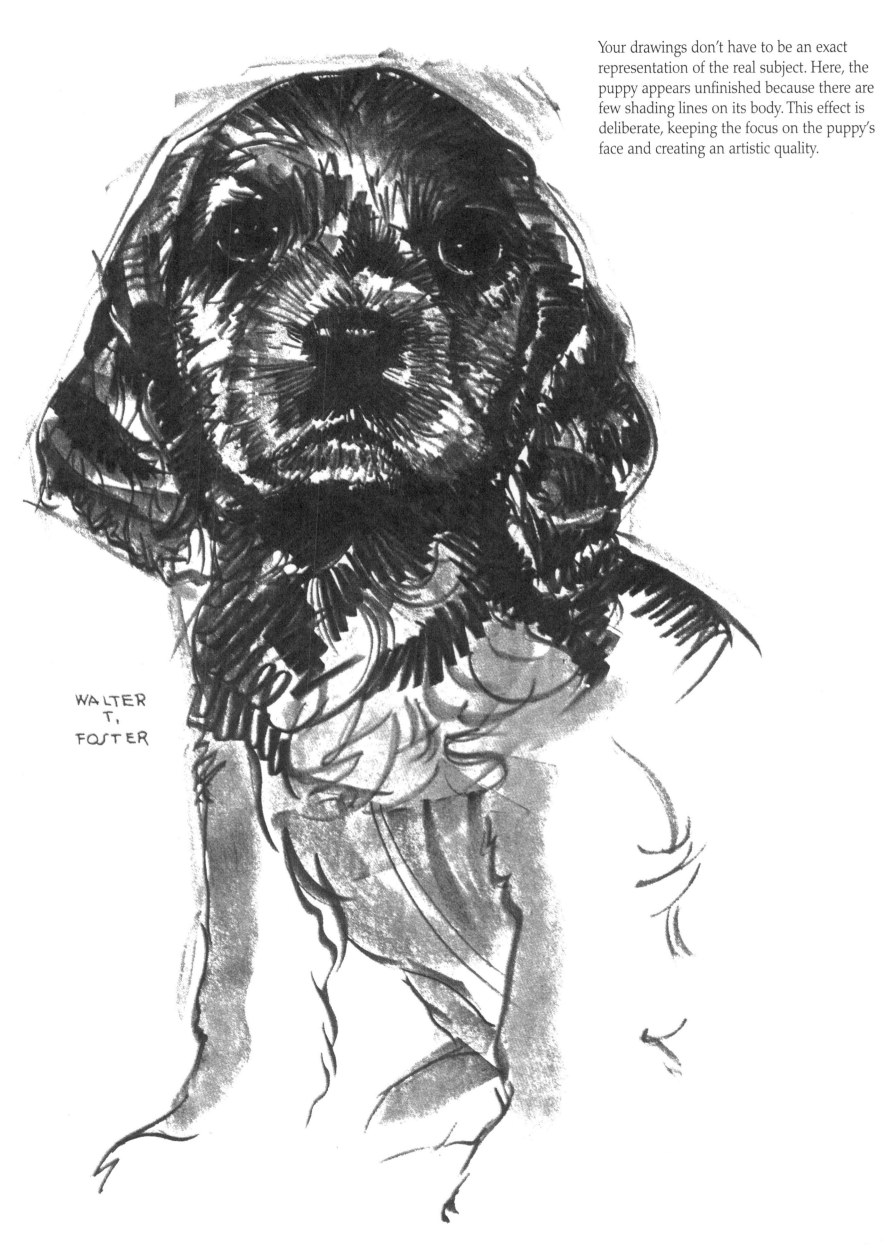

Your drawings don't have to be an exact representation of the real subject. Here, the puppy appears unfinished because there are few shading lines on its body. This effect is deliberate, keeping the focus on the puppy's face and creating an artistic quality.

WALTER T. FOSTER

English Bulldog

The powerful English bulldog, with its stocky, muscular body, is a fun, challenging breed to draw. Even though the pronounced underbite of this dog gives it a gruff expression, it is known to be very affectionate and docile.

In step A, block in the general outline with short, straight lines. Keep the legs short and bowed to give the dog its compact, stocky appearance. As you sketch the features in step B, study the low placement of the eyes, as well as how the nose is pushed into the face.

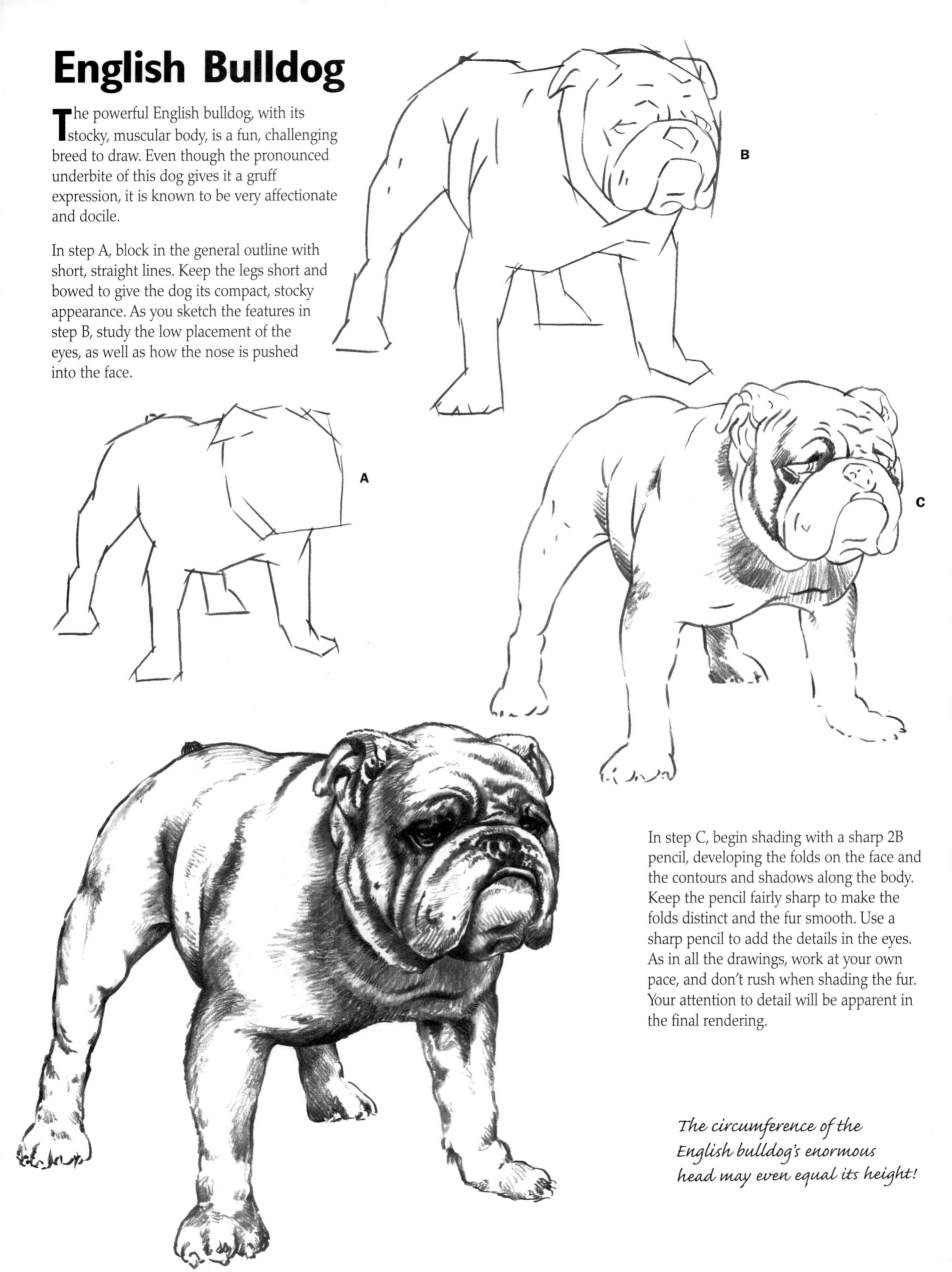

In step C, begin shading with a sharp 2B pencil, developing the folds on the face and the contours and shadows along the body. Keep the pencil fairly sharp to make the folds distinct and the fur smooth. Use a sharp pencil to add the details in the eyes. As in all the drawings, work at your own pace, and don't rush when shading the fur. Your attention to detail will be apparent in the final rendering.

The circumference of the English bulldog's enormous head may even equal its height!

Miniature Schnauzer

The miniature schnauzer's bushy eyebrows and long beard give it a striking appearance. Almost square in profile, the miniature schnauzer (along with its larger counterparts, the standard and giant schnauzers) exhibits a straight, level back and well-developed legs.

As you block in the body in step A, make the face wider around the cheeks to accommodate the full beard. Next, add triangle shapes on top of the head so the ears appear to flop forward. In step B, place the wide-set eyes and broad nose, and suggest a furry outline.

Slowly lay in the coat with quick strokes along the back in step C. Make certain the fur closest to the face is dark, so the outline of the face is visible. Fewer strokes are needed on the chest and legs because the fur color is generally lighter in these areas. You can also mold a kneaded eraser into a sharp edge and "draw" with it in the direction of the fur to create highlights.

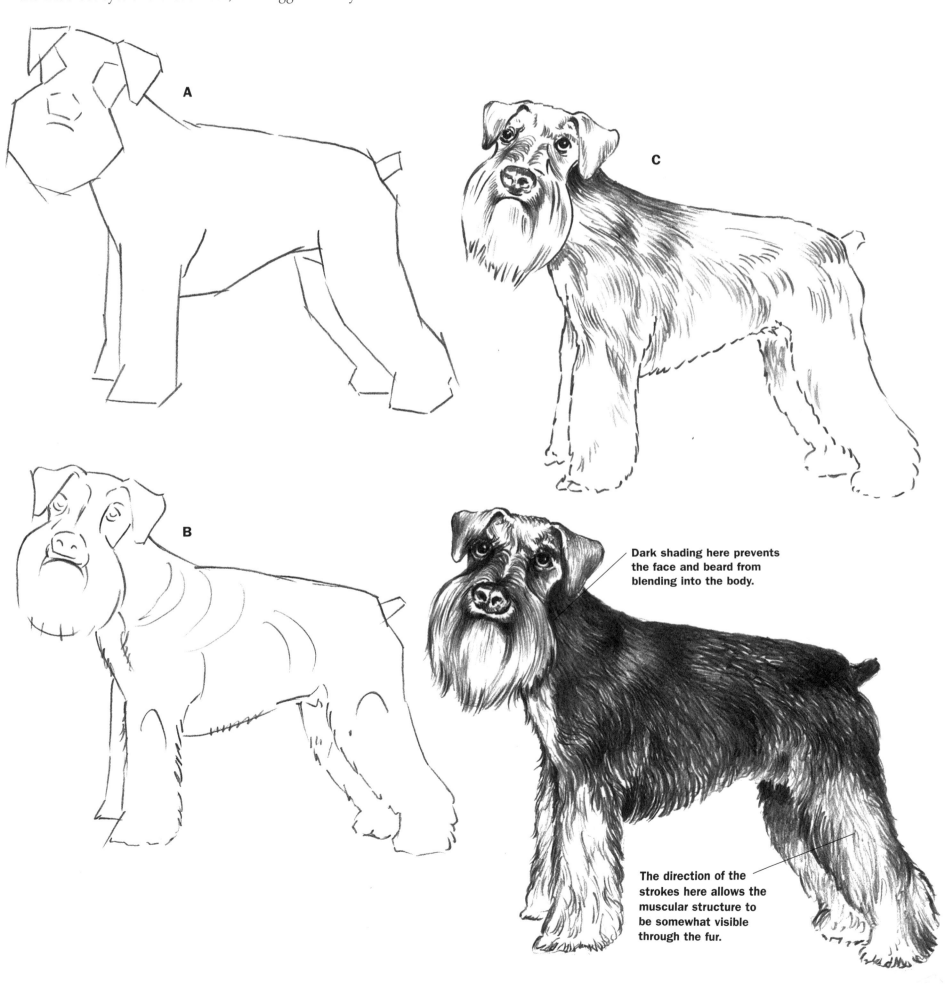

A

B

C

Dark shading here prevents the face and beard from blending into the body.

The direction of the strokes here allows the muscular structure to be somewhat visible through the fur.

Shar-Pei Puppy

The Shar-Pei is probably best known for its loose folds of skin. These wrinkles seem to give this breed a worried expression. The puppy shown here has looser skin than an adult; eventually, the body will fill out, and the folds will become less obvious.

As you block in the dog's shape in step A, use short strokes placed at wide angles to sketch the outline. To develop the folds in step B, start by lightly shading inside the creases. Give equal attention to each fold so the dog appears realistic. Continue to develop the shading with short slash-marks in step C, keeping the values darker between the folds. See page 3 for more detailed instructions on rendering this type of texture.

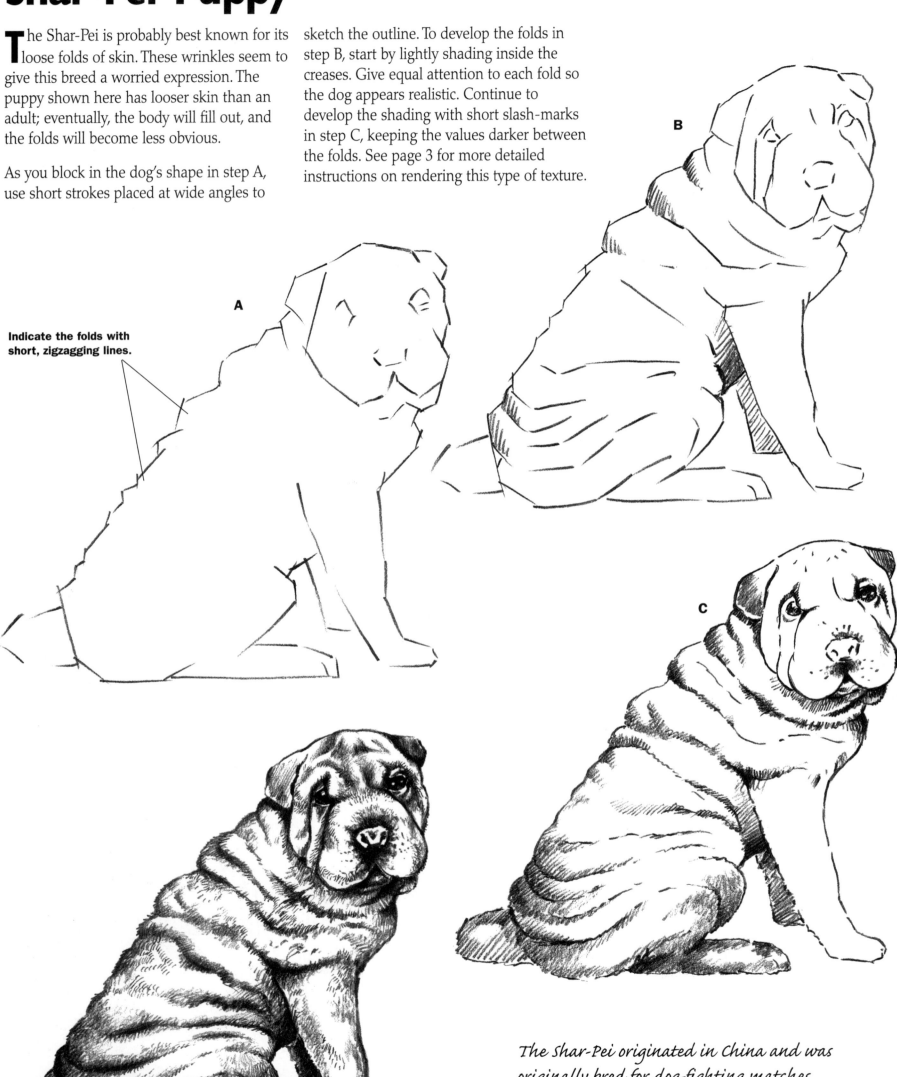

Indicate the folds with short, zigzagging lines.

The Shar-Pei originated in China and was originally bred for dog-fighting matches.

Old English Sheepdog

The most distinctive feature of the Old English sheepdog is its long fluffy coat, which sometimes covers the dog's eyes and hides the ears. This particular rendering doesn't require many fine details, but the coat does require much attention.

Lay down a basic outline in step A, adding some suggestions of hair in step B. Keep your lines loose and free.

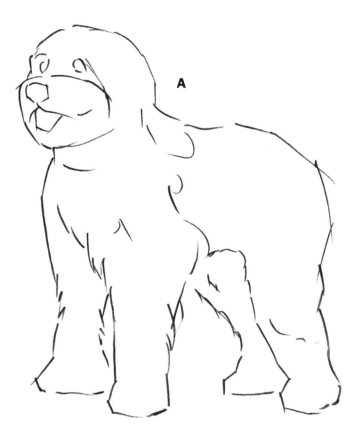

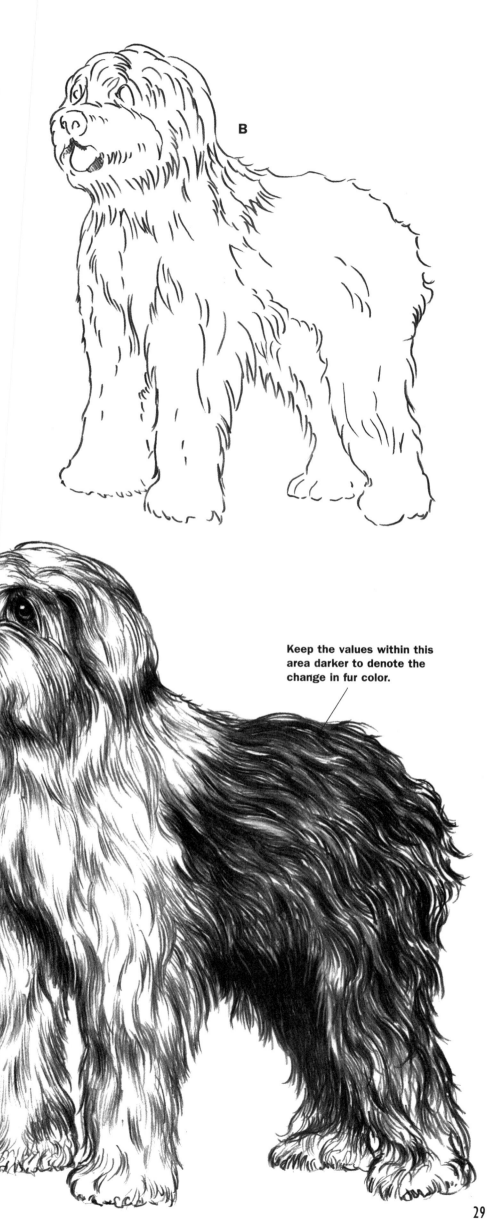

Keep the values within this area darker to denote the change in fur color.

As you begin to develop the fur, notice how the nose, tongue, and eyes differ in texture; they are quite smooth in contrast. You can use a blunt-pointed pencil to lay in the fur, adding more shading layers to the back end of the body to indicate the darker fur color. Enhance the fur texture by molding a kneaded eraser into a sharp edge and erasing with the edge in the direction of the strokes. This brings out highlights and creates shadows between the strands.

The hair of the Old English sheepdog is so long and shaggy that you can barely discern where the ears are located.

Chow Chow

The very recognizable chow chow can have a rough or smooth coat, which should be rendered with a soft, sharp pencil. Notice how finely detailed this rendering appears; each hair of the coat is carefully drawn. It should be obvious what this dog's coat would feel like.

In steps A and B, sketch a preliminary outline of the dog, and add the facial features. With a sharp pencil, begin shading the darkest areas within the fur in step C. This fur texture shows many highlights, so the kneaded eraser will also be useful for enhancing the realism of the drawing.

Begin shading in the areas that recess into the fur.

A few strokes curving toward the center of the tail makes it appear bushy and light in color.

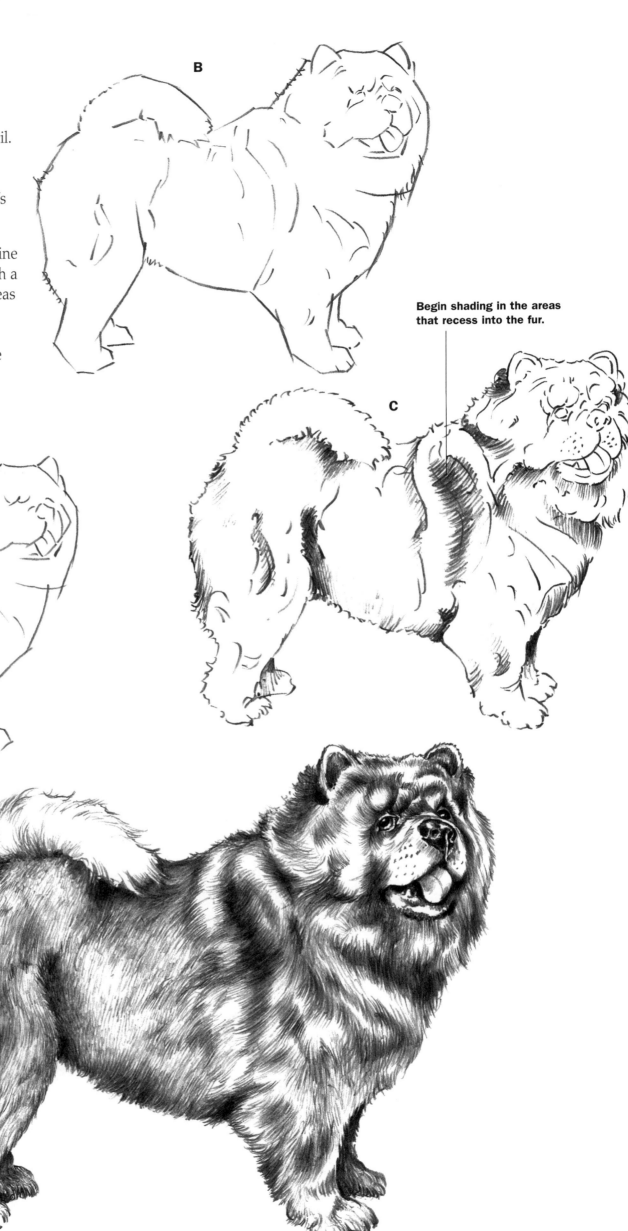

Bouvier des Flandres

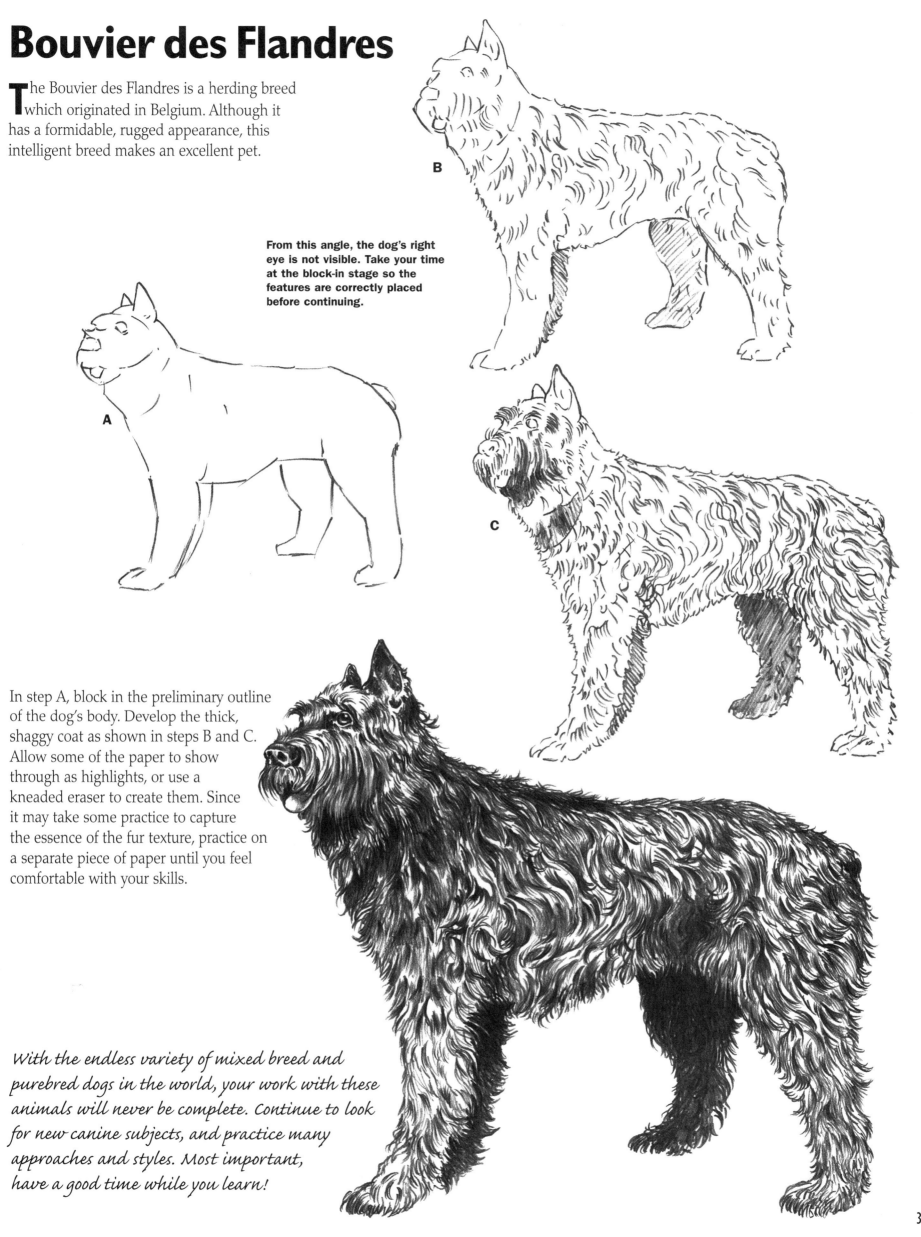

The Bouvier des Flandres is a herding breed which originated in Belgium. Although it has a formidable, rugged appearance, this intelligent breed makes an excellent pet.

From this angle, the dog's right eye is not visible. Take your time at the block-in stage so the features are correctly placed before continuing.

In step A, block in the preliminary outline of the dog's body. Develop the thick, shaggy coat as shown in steps B and C. Allow some of the paper to show through as highlights, or use a kneaded eraser to create them. Since it may take some practice to capture the essence of the fur texture, practice on a separate piece of paper until you feel comfortable with your skills.

With the endless variety of mixed breed and purebred dogs in the world, your work with these animals will never be complete. Continue to look for new canine subjects, and practice many approaches and styles. Most important, have a good time while you learn!

More Ways to Learn

Artist's Library

AL03 · AL35 · AL36

The **Artist's Library** series offers both beginning and advanced artists many opportunities to expand their creativity, conquer technical obstacles, and explore new media. You'll find in-depth, thorough information on each subject or art technique featured in the book. The books are written and illustrated by well-known artists who are qualified to help take eager learners to new levels of expertise.

Paperback, 64 pages, 6-1/2" x 9-1/2"

Collector's Series

CS01 · CS02 · CS03

The **Collector's** series books are excellent additions to any library, offering a comprehensive selection of projects drawn from the most popular titles in our How to Draw and Paint series. These books take the fundamentals of a particular medium, then further explore the subjects, styles, and techniques of featured artists.

CS01, CS02, CS04: Paperback, 144 pages, 9" x 12"
CS03: Paperback, 224 pages, 10-1/4" x 9"

How to Draw and Paint

HT264 · HT265 · HT266 · HT268

The **How to Draw and Paint** series is an extensive collection of stunning titles, covering every subject and medium and meeting any beginning artist's needs. Specially written to encourage and motivate, these books offer essential information in an easy-to-follow format. Lavishly illustrated with beautiful drawings and gorgeous art, this series both instructs and inspires the aspiring artist.

Paperback, 32 pages, 10-1/4" x 13-3/4"

Walter Foster products are available at art and craft stores everywhere. Write or call for a FREE catalog that includes all of Walter Foster's titles. Or visit our website at www.walterfoster.com

Walter Foster

Walter Foster Publishing, Inc. · 23062 La Cadena Drive · Laguna Hills, CA 92653 · (800) 426-00